MONET

THE EARLY YEARS

A Pictorial

PICTORIAL SERIES

**Fine Arts Museums
of San Francisco**
Legion of Honor

INTRODUCTION

Before his success, before there was even the term "Impressionism," Claude Monet labored to define his style and promote himself as an artist. Two forces drove him: his will to be a painter and his desire to become critically and commercially successful. During his early career, Monet struggled to provide food and shelter for himself and his family while creating innovations that would turn the art world upside down.

Monet: The Early Years examines the first fourteen years of Monet's professional career, beginning in 1858 with the first painting he exhibited, and ending in 1872, the year he settled in Argenteuil and began a new artistic phase, creating the works that would soon become synonymous with Impressionism.

Who was this young man from a small coastal community, trying to establish himself in the Parisian art world in the 1860s? Claude Monet (1840–1926) was born in Paris and grew up in the town of Le Havre, in Normandy. As a student he took drawing lessons and excelled at caricature. His work caught the eye of Eugène Boudin, an older artist who introduced Monet to painting out of doors and to the idea that he, too, could make a living as a painter. When he was twenty (see fig. 1), Monet moved to Paris to pursue this career.

As with any other kind of work, Monet had to figure out the rules to thrive. He knew that acceptance to the Salon was the most assured road to success. The Salon was the official, juried art exhibition of the Académie des Beaux-Arts in Paris, the dominant arts institution in France. Before the rise of private art dealers, exhibiting at the Salon was the best way for artists to gain recognition and make sales. Both the public and the critics—around three hundred thousand people annually—flocked to the Salons. For the artists, who competed furiously for the right to exhibit, success at the Salon could lead to fame, wealth, social standing, and influence. Buyers preferred pictures presenting pretty nudes, sentimental stories, religious subjects, heroic deeds, patriotic scenes, and touching tales (see fig. 2).

The twenty-four-year-old Monet was successful with his first submission to the Salon in 1865, *The Pointe de la Hève at Low Tide* (p. 25). This work was also praised in the press: one reviewer, identified only as "Pigalle," wrote, "Monet, unknown yesterday, has immediately

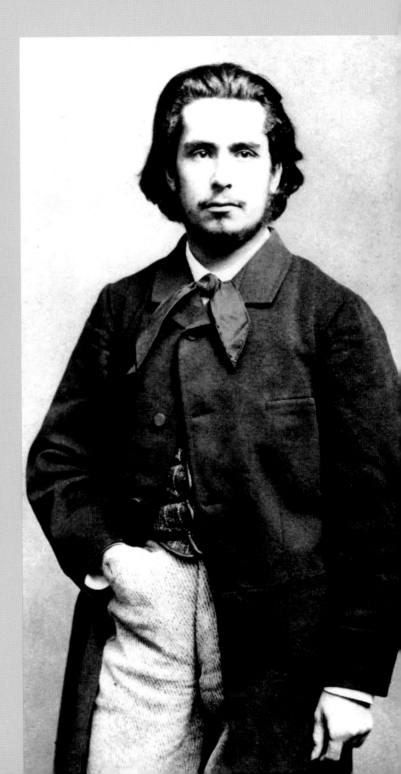

Fig. 1. Étienne Carjat, portrait of Claude Monet, ca. 1864

made a name for himself with this single painting." Monet's initial success at the Salon, however, was followed by many rejections. As Monet described it years later, the Academy had identified his circle of painters as "a gang with pretensions to new and revolutionary art" that if officially accepted could "mean the end of great art and tradition." Salon approval in 1865 and 1866 did not guarantee the same for his 1868 submission of *The Jetty at Le Havre* (present location unknown), which was rejected. The young artist had invested a significant sum of money in this large-scale canvas and had to beg his family for money to survive. Monet actively solicited advice from fellow painters on how to make his paintings acceptable, yet it was difficult to know what would please the Salon jurors.

Financial instability was a constant worry for Monet during these years. In 1865 he had begun another painting to be submitted to the Salon, the ambitious *Luncheon on the Grass* (p. 6). Monet knew that scale was important to attract attention at the Salon, and this canvas measured more than thirteen by ten feet. Although the work was too large to execute out of doors, he painted many preparatory sketches outside in nature, resulting in a bravado demonstration of his command of landscape painting. He populated the picnic scene with life-size figures in modern dress; models were his friends and acquaintances, including his future wife Camille Doncieux. Unfortunately, Monet was unable to complete the canvas in time to submit for the Salon. Needing to pay his rent, Monet gave the canvas to his landlord as collateral. The landlord kept the painting in a damp basement, where parts of the canvas mildewed. When Monet retrieved the painting in 1884, he had to cut away the destroyed parts. Only two fragments remain.

Some art historians credit Camille with giving Monet the confidence to attempt a work on the scale of *Luncheon on the Grass*. Monet met her in 1865 when she was eighteen and working as a studio model. He was twenty-five. When he was unable to finish that painting in time for the Salon, he began work on another—

Camille (Woman in a Green Dress) (1866, Kunsthalle, Bremen)—which Camille may have helped to create by providing Monet with fashion prints and possible suggestions for the pose. This painting was not only accepted to the Salon of 1866, it was well received.

Despite Monet's varied artistic success during these early years, his paintings made prior to the first Impressionist group show in 1874 demonstrate striking authority. Examples such as *On the Bank of the Seine, Bennecourt* (p. 34) reveal his working process and his willingness to let the viewer's eye do the work. Monet divided this composition diagonally in half. The deep greens of the foreground add a sense of weight to the riverbank that contrasts with the pastels of the sun-drenched background. Yet within this composition, there are areas where the artist applied paint in startling ways. For example, the bright green patch in the foreground reads purely as a brushstroke and contrasts directly with the darker greens, which are applied in an even pattern, evoking blades of grass. The slight tonal variation between the flesh tone of the figure's face and the putty reflection of a roof of a building across the bank is another point where the viewer's eye works, filling in the distance needed to make this juxtaposition of two squares of color read as a face and a roof.

Other works, such as *The Magpie* (p. 21), reveal Monet's nuanced mastery of color. While at first glance the painting reads as a study in white, upon closer examination one discovers a careful orchestration of pink and blue undertones. This variation in tonal quality adds a sense of warmth to the composition while simultaneously creating depth through deep shadows. Monet sought from the start to create new and unconventional ways of representing the modern visual experience. In doing so he invented a new pictorial language for the modern era.

Fig. 2. Gustave Le Gray, photograph of the Salon of 1852. Salt paper print, 7 ⅝ x 9 ¼ in. (19.4 x 23.6 cm). Musée d'Orsay, Paris

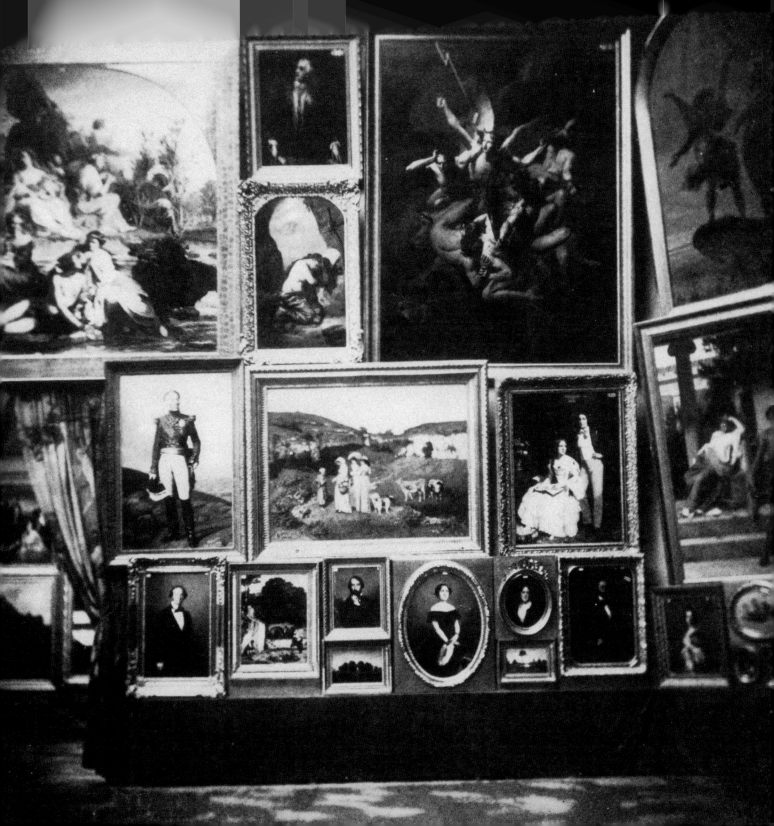

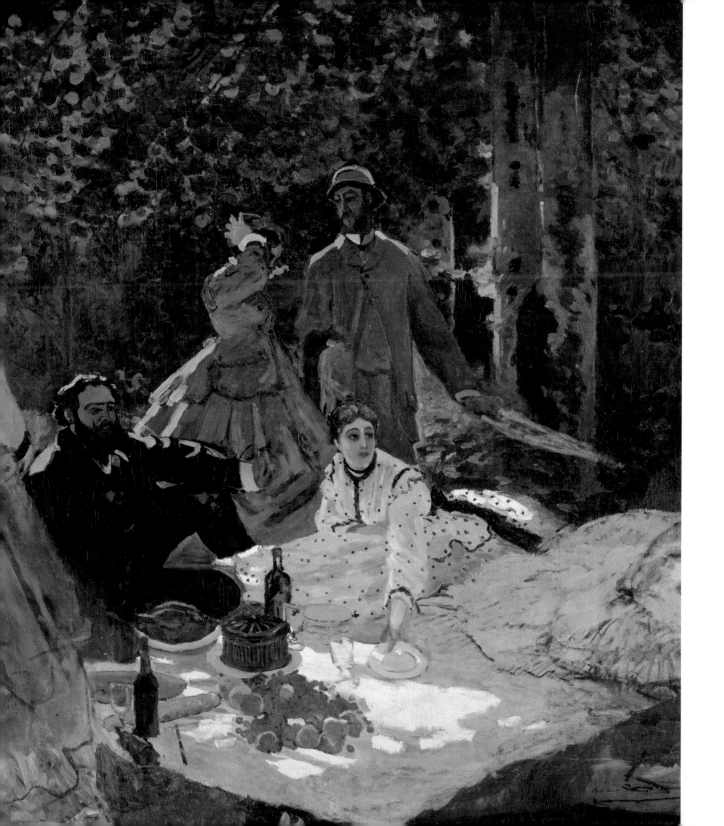

No one appears more frequently in Monet's early paintings than his first wife, Camille.

Before they wed, Camille was his mistress, during which time she endured considerable hardship. Living in poverty and without family support, she was by 1867 pregnant with their first child, unmarried, and living alone in Paris in a one-room apartment paid for by Monet. After the birth of their son, Jean, Monet took the opportunity to paint the child in a series of tender portraits (see pp. 8 and 9). The couple finally married in 1870. They honeymooned—with Jean, now a toddler—on the Normandy coast at the fashionable resort of Trouville, where they stayed at a modest hotel. Monet, always working, painted many scenes of Camille on the beach (see pp. 10 and 11).

In October of that year, avoiding both creditors and the Franco-Prussian War, the Monets left France and settled in London. There, Claude met the Parisian art dealer Paul Durand-Ruel, who helped to have Monet's work shown and sold in London, providing the artist with some economic relief. While in London, Monet painted the chilly, humid winter weather in paintings such as *Hyde Park* (p. 12).

In 1871—with France still reeling from the violence and chaos of the war, which ended that year, and the insurrection of the Paris Commune—Monet and his family remained expatriates, leaving England for Holland and settling in Zaandam for four months. While there Monet produced around two dozen paintings of windmills and water, including *Houses by the Zaan at Zaandam* (p. 13).

Upon their return to France later that year, the Monets rented a house in the Parisian suburb of Argenteuil that would become their home for the next five years. Monet achieved greater financial stability as Paul Durand-Ruel became a regular purchaser of his paintings.

Luncheon on the Grass (fragment; central panel), 1865–1866. Oil on canvas, 97 ⅝ x 85 ⅜ in. (248 x 217 cm). Musée d'Orsay, Paris

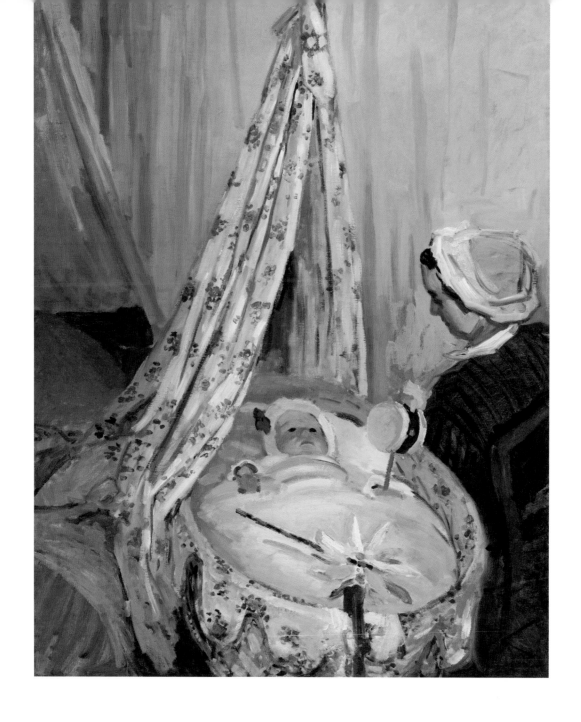

The Cradle, 1867. Oil on canvas, 45 ¾ x 34 ⅞ in. (116.2 x 88.8 cm).
National Gallery of Art, Washington, DC, Collection of Mr. and Mrs. Paul Mellon

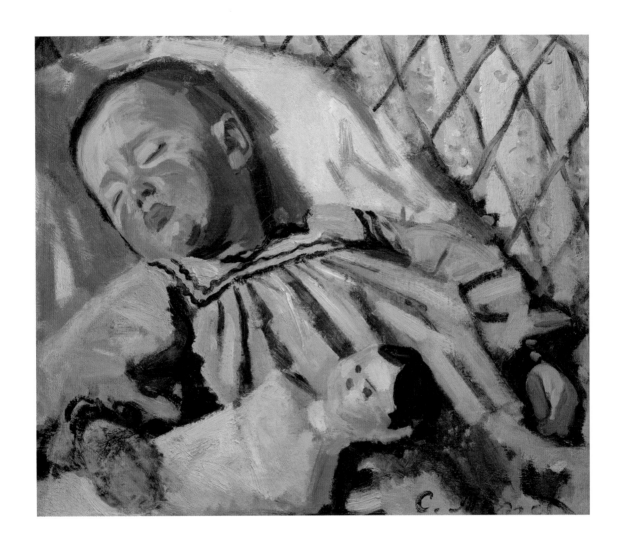

Jean Monet Sleeping, 1868. Oil on canvas, 16 ¾ x 19 ⅝ in. (42.5 x 50 cm). Ny Carlsberg Glyptotek, Copenhagen

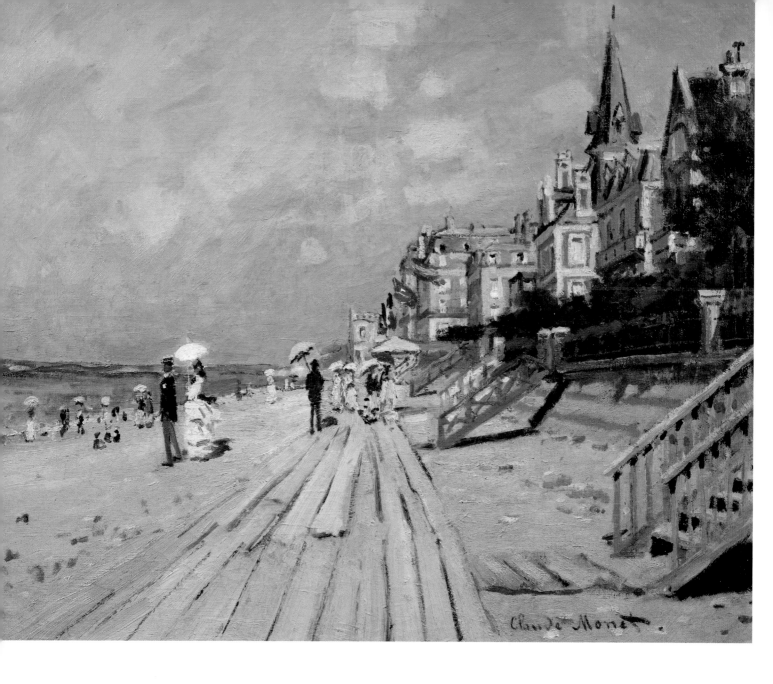

The Beach at Trouville, 1870. Oil on canvas, 21 ¼ x 25 ½ in. (54 x 64.8 cm).
Wadsworth Atheneum Museum of Art, Hartford, Connecticut, The Ella Gallup Sumner and Mary Catlin Sumner Collection Fund

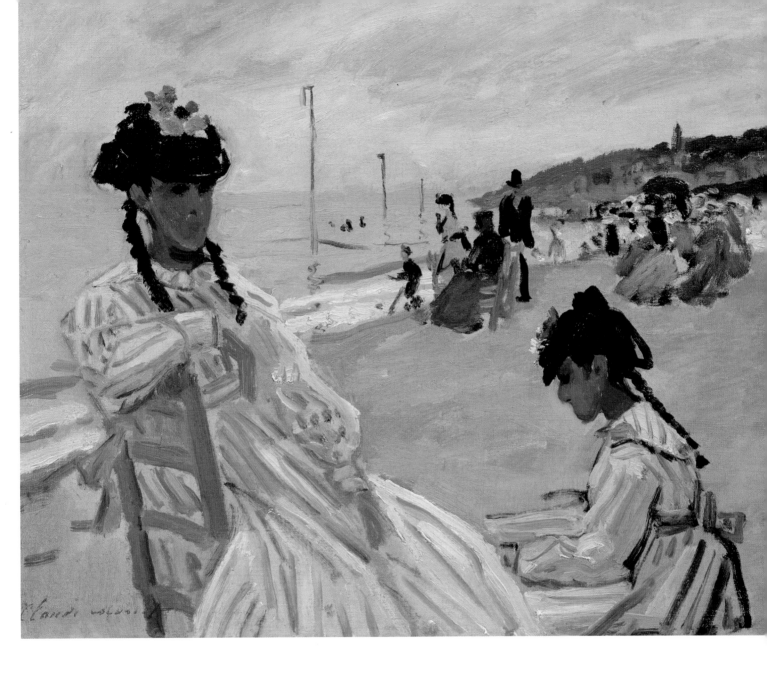

On the Beach at Trouville, 1870. Oil on canvas, 15 x 18 ⅛ in. (38 x 46 cm).
Musée Marmottan Monet, Paris

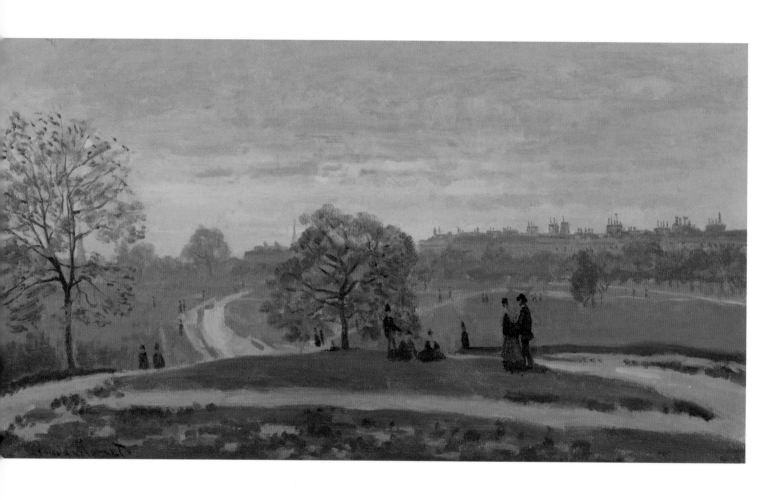

Hyde Park, 1871. Oil on canvas, 15 ⅞ x 29 ⅛ in. (40.5 x 74 cm).
Museum of Art, Rhode Island School of Design, Providence, Gift of Mrs. Murray S. Danforth

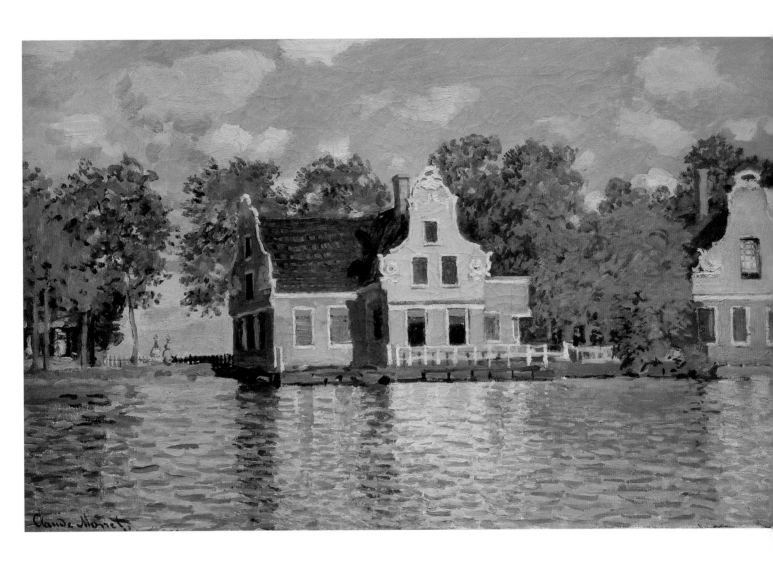

Houses by the Zaan at Zaandam, 1871. Oil on canvas, 18 ¾ x 29 in. (47.5 x 73.5 cm).
Städel Museum, Frankfurt am Main

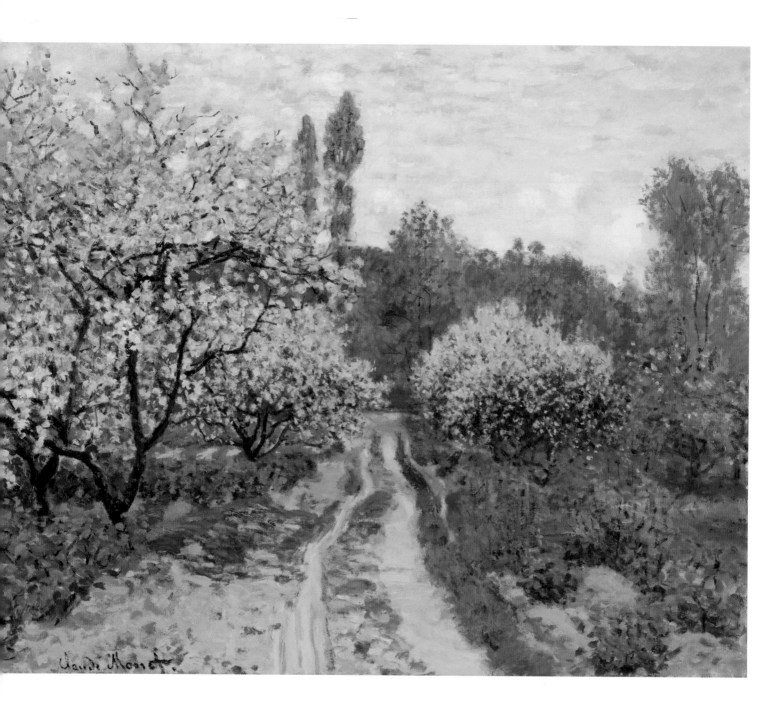

Even in his earliest works, Monet's considerable skill in portraying a great variety of natural effects is readily apparent.

In 1863, Monet, at the age of twenty-three, traveled from Paris to Fontainebleau. This majestic forest, once the private reserve of the kings, had become a tourist destination a short railway trip from Paris. Monet endeavored to paint entirely out of doors to capture nature directly on this and future trips to Fontainebleau.

In paintings such as *An Oak at Bas-Bréau (The Bodmer)* (p. 19), Monet deployed several techniques that would evolve into hallmarks of his mature style. First the artist dramatically cropped the tree, bringing the viewer close up and into the deep shadows created by the enormous branches overhead. The background of the composition is defined by multiple tones of light green, flattening any sense of depth beyond the oak. Perhaps most striking is the artist's ability to capture the dancing quality of shadows through his varied use of color; in the foreground, the forest floor is covered in muddied grays, yellows, and greens, creating a sense of a soft light breaking through the forest canopy. In contrast to this restrained study of light and color, Monet captured direct sunlight by using intense white, as seen on the trunk of the oak. Here we can see him as a fearless colorist who has confidently dedicated the center of his composition to the glare of the sun.

Monet's practice of painting outside was facilitated by the recent innovation of paint in tubes and portable easels. During his early years, the artist also began his practice of returning to a site again and again to experiment with many different ways of registering light under various atmospheric conditions. He also brought his fascination with nature to his own domestic sphere, cultivating a garden at Argenteuil that he depicted in such works as *Apple Trees in Blossom* (opposite).

Apple Trees in Blossom, 1872. Oil on canvas, 22 ½ x 27 ⅛ in. (57 x 69 cm). Union League Club of Chicago

View near Rouelles, 1858. Oil on canvas, 18 x 25 ½ in. (46 x 65 cm).
Maranuma Art Park, Asaka, Japan

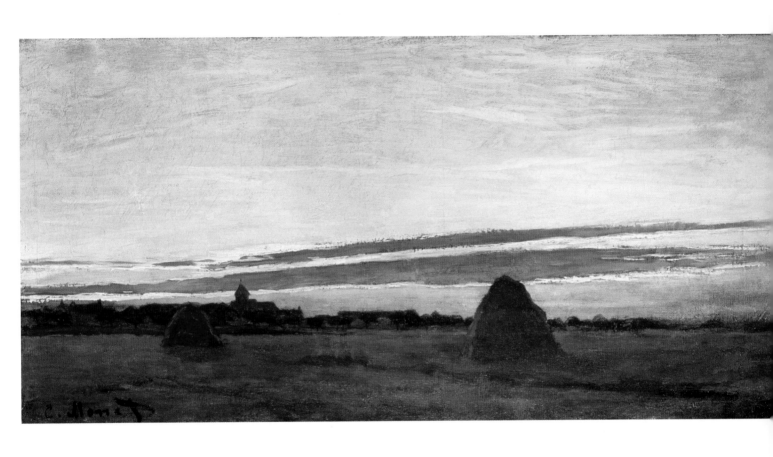

Grainstacks at Chailly at Sunrise, 1865. Oil on canvas, 11 ⅞ x 23 ⅝ in. (30.2 x 60.5 cm).
The San Diego Museum of Art, Museum purchase

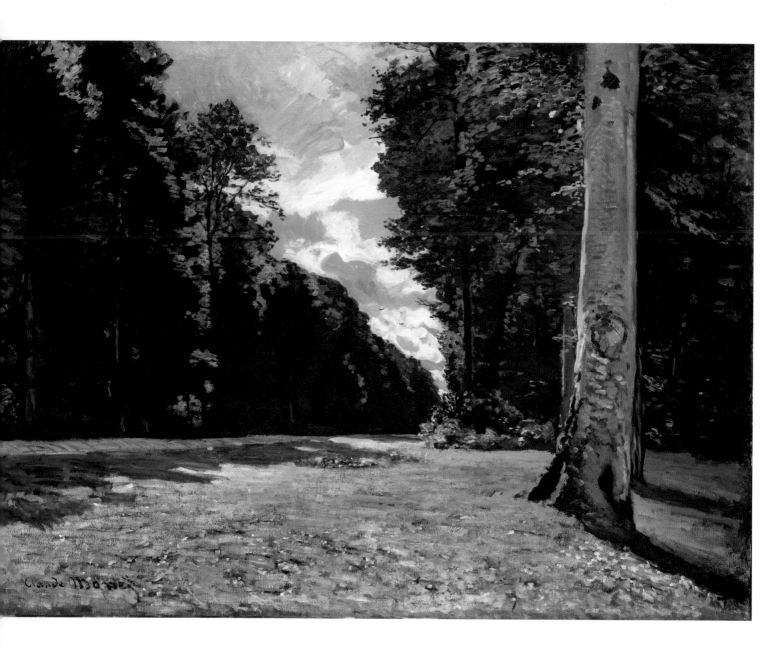

The Chailly Road in the Forest of Fontainebleau, 1865. Oil on canvas, 38 ¼ x 51 ⅜ in. (97 x 130.5 cm).
Ordrupgaard, Copenhagen

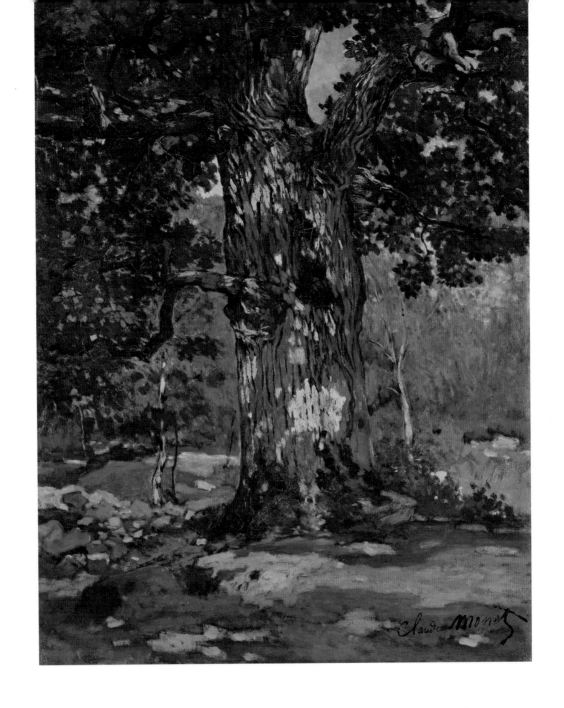

An Oak at Bas-Bréau (The Bodmer), 1865. Oil on canvas, 21 ⅜ x 16 ⅛ in. (54.4 x 41 cm).
Private collection

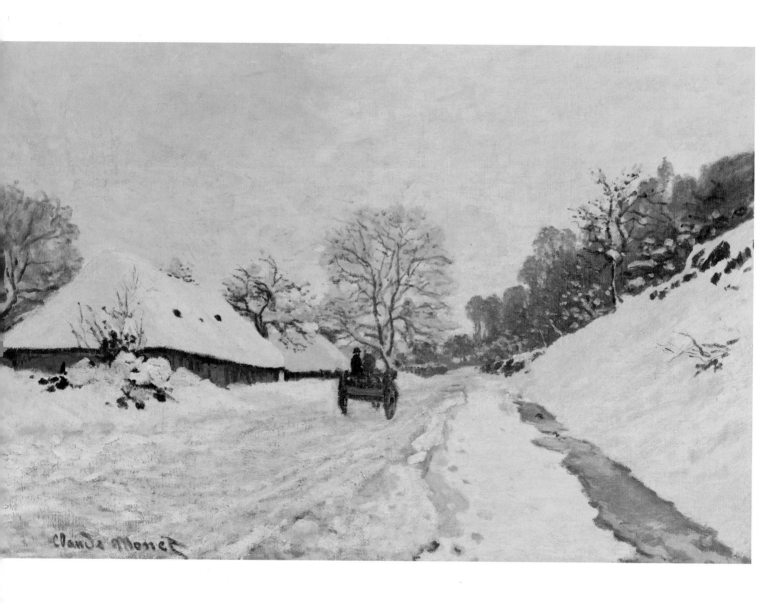

A Cart on the Snowy Road at Honfleur, 1865. Oil on canvas, 25 ⅝ x 36 ⅜ in. (65 x 92.5 cm).
Musée d'Orsay, Paris, Bequest of comte Isaac de Camondo

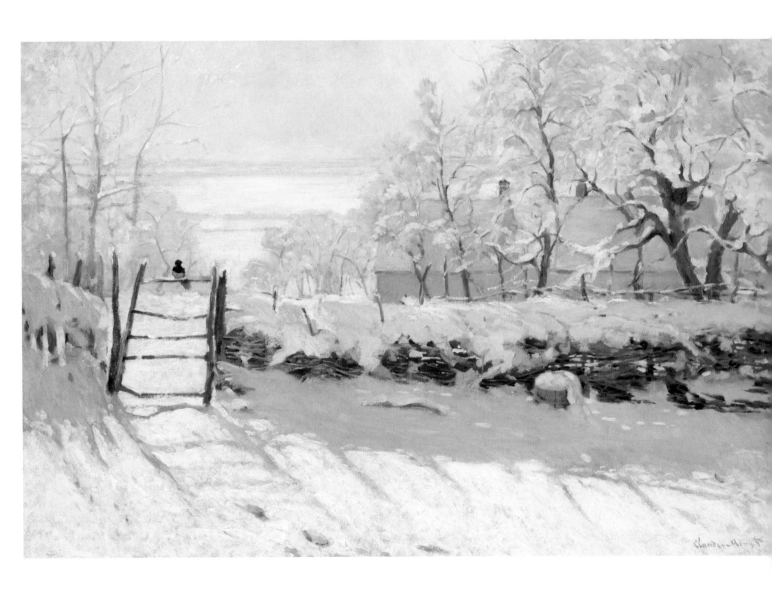

The Magpie, 1869. Oil on canvas, 35 ⅛ x 51 ⅛ in. (89 x 130 cm).
Musée d'Orsay, Paris

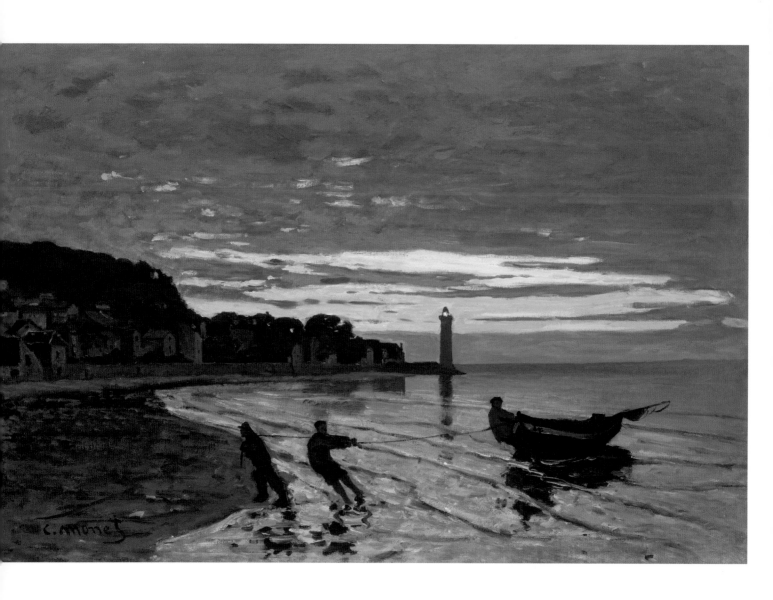

Monet's desire to paint water in various seasons and under various conditions, whether stormy or serene, is a hallmark

that dates to his earliest works, many of which prominently feature the Normandy coast. *The Porte d'Amont, Étretat* (p. 28) demonstrates the dramatic backdrop of this small fishing village, where he lived in the winter of 1868–1869.

There he focused on painting the unique rock formations, where the tide and wind had created fantastic arches such as the one seen here. To reach this vantage point, Monet descended a seldom-used rock path that provided access to a bank only visible at low tide. From this precarious position, Monet captured the majestic mass of white layered chalk as he looked towards the setting sun, the scene backlit and filled with the diffused light of dusk in tones of vibrant pink, violet, and white. The rock formation is rendered in similar hues, contrasting with the heavy black that depicts wet stone revealed by the ebbing tide. This composition offers an unparalleled opportunity to study not only Monet's employment of color but also his nuanced use of brushstrokes. The firm and steady horizontal brushstrokes of the cliffs contrast with the fleeting horizontal bands of color that fill the sky. The implied cycle of the tides, as well as the impending darkness promised by the obscured setting sun, infuses this work with a sense of cyclical time, which is rebuffed by the enduring mass of the cliff itself.

Monet returned to paint these magnificent geological features at many different times in his life, and the Normandy coast was a favorite subject throughout his career. In fact, his 1874 seascape of the port of Le Havre (*Impression, Sunrise*; Musée Marmottan Monet, Paris) is the painting whose title lent itself to the artistic style that would come to be known as Impressionism.

Towing of a Boat at Honfleur, 1864. Oil on canvas, 21 ¾ x 32 ⅜ in. (55.2 x 82.1 cm). Memorial Art Gallery, University of Rochester, New York, Gift of Marie C. and Joseph C. Wilson

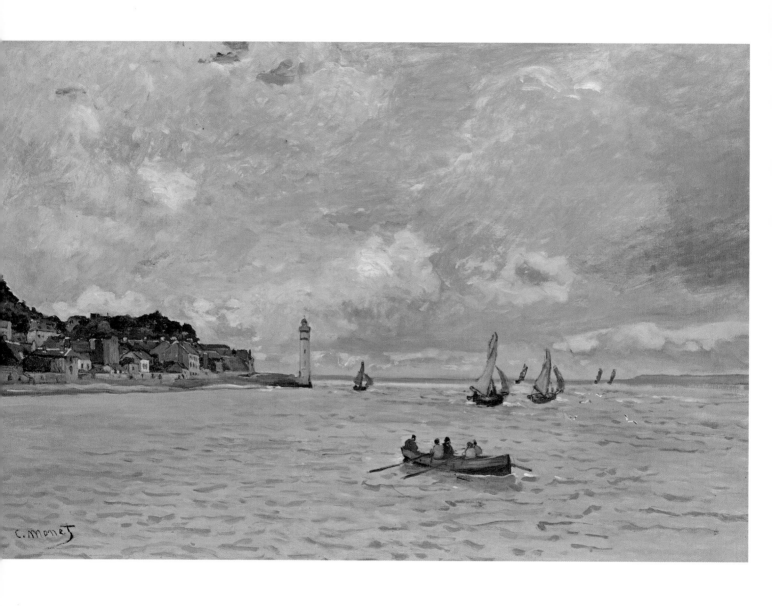

Le Phare de l'Hospice, 1864. Oil on canvas, 21 ¼ x 31 ⅞ in. (54 x 81 cm).
Kunsthaus Zürich

24

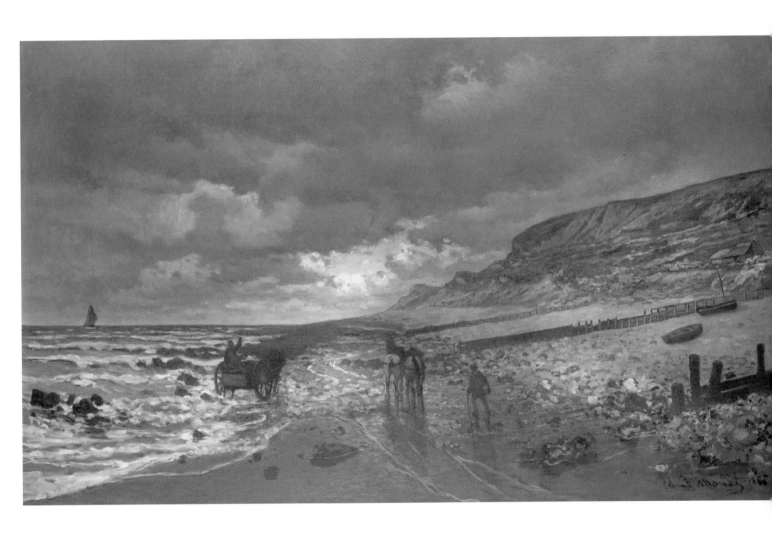

The Pointe de la Hève at Low Tide, 1865. Oil on canvas, 35 ½ x 59 ¼ in. (90.2 x 150.5 cm).
Kimbell Art Museum, Fort Worth, Texas

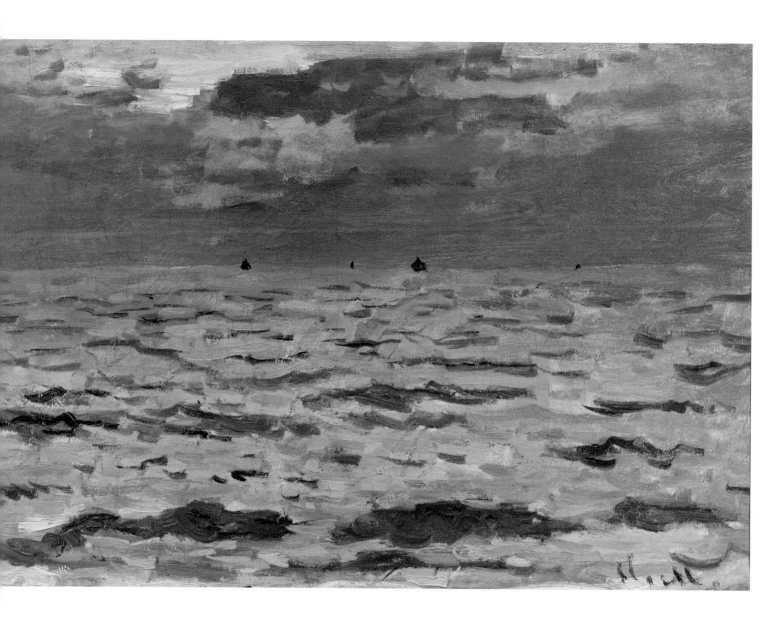

Seascape, ca. 1866. Oil on canvas, 16 ⅞ x 23 ⅜ in. (43 x 59.5 cm).
Ordrupgaard, Copenhagen

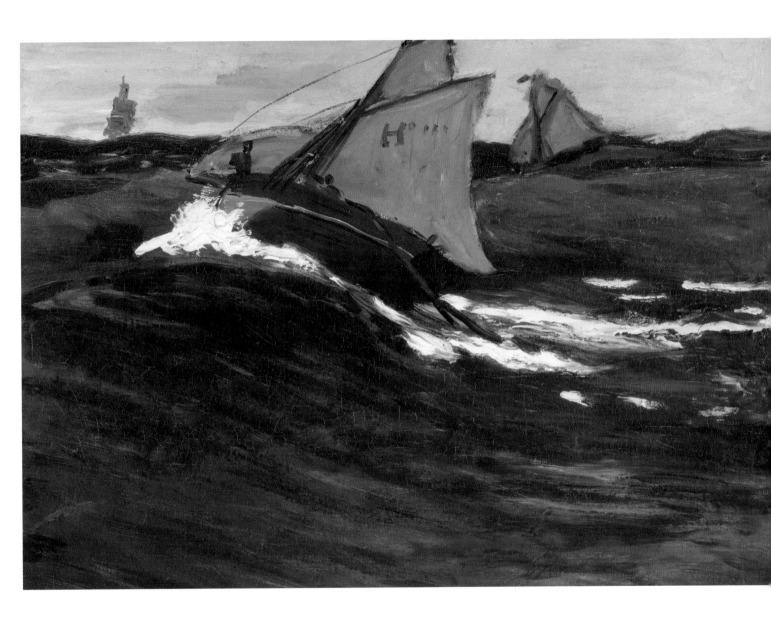

The Green Wave, ca. 1866–1867. Oil on canvas, 19 ⅛ x 25 ½ in. (48.6 x 64.8 cm).
The Metropolitan Museum of Art, New York, H. O. Havemeyer Collection, Bequest of Mrs. H. O. Havemeyer

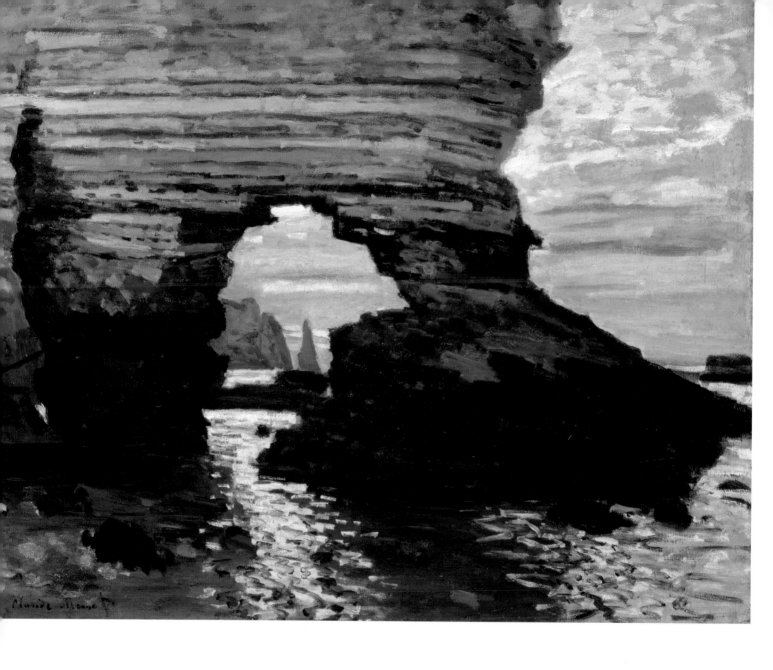

The Porte d'Amont, Étretat, ca. 1868–1869. Oil on canvas, 31 ⅛ x 38 ¾ in. (79.1 x 98.4 cm).
Harvard Art Museums / Fogg Museum, Cambridge, Massachusetts, Gift of Mr. and Mrs. Joseph Pulitzer, Jr.

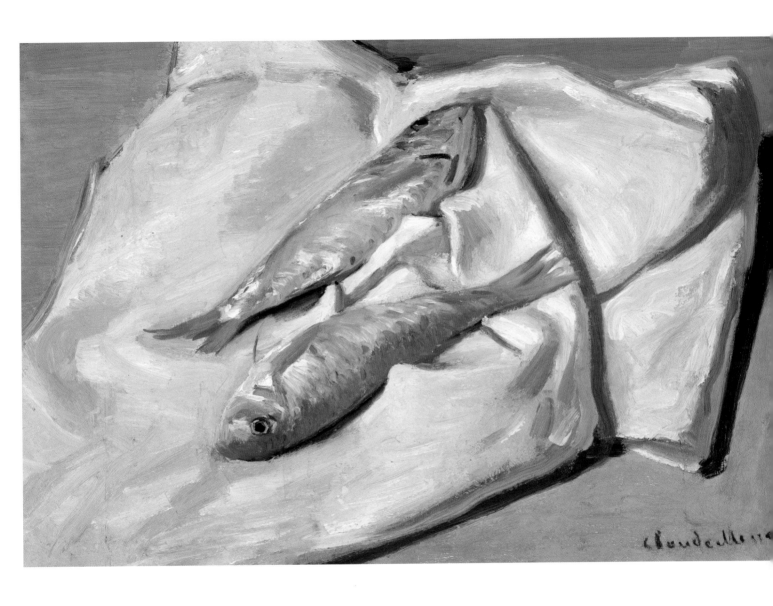

Red Mullets, 1869. Oil on canvas, 14 x 19 ¾ in. (35.5 x 50 cm).
Harvard Art Museums / Fogg Museum, Cambridge, Massachusetts, Friends of the Fogg Art Museum Fund

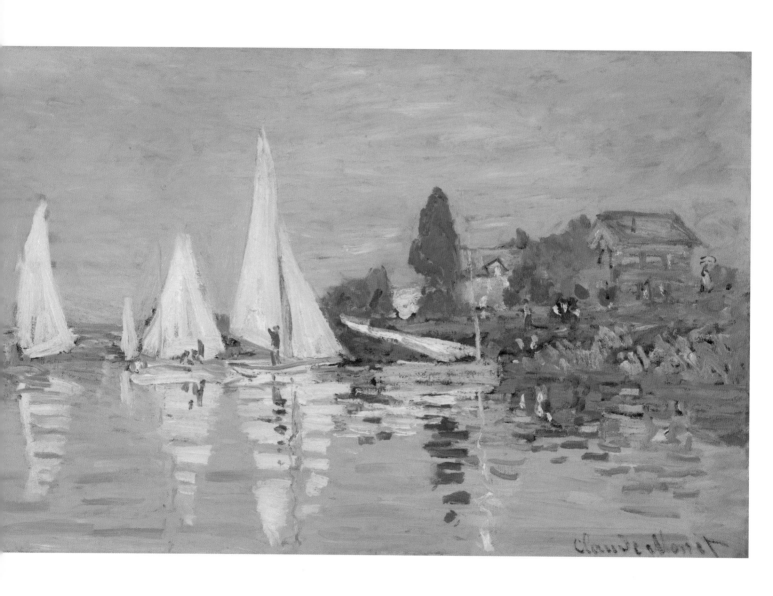

Between 1853 and 1870, Paris was in the midst of a vast urban redesign that included the demolition of overcrowded neighborhoods dating to medieval times.

The construction of wide avenues, parks and squares, and new apartment buildings transformed Paris into a modern city. Monet was fascinated by the manifestations of modern urban life on view throughout Paris. He requested, from the French superintendent of the arts, special access to an exterior colonnade of the Musée du Louvre to paint views of the center of the city, such as *Saint-Germain l'Auxerrois* (p. 32). There the young artist quite literally turned his back to the great repository of art on display in the museum and painted the present.

Meanwhile, in the suburbs of Paris, a middle class seeking refuge from the intensity of city living flocked to leisure locations easily accessible by train. Monet's *La Grenouillère* (p. 37), portraying a popular bathing spot on the Seine, conveys the sensation of the site; the artist carefully captured through color and brushstrokes the effects of light, rendering a composition infused with a sense of pleasure. The men and women sit leisurely at the café, converse under the central tree, partake in swimming, and prepare for a boat ride out on the sun-drenched water. Yet the true subject of this painting is perhaps the river itself. While the activity of the figures is evoked through quick, energetic dashes of the brush, Monet lavished attention on the water, its multiple colors, its reflections, and its depths.

Upon settling with his family in Argenteuil, in 1872, Monet painted many works in that Parisian suburb on the Seine, often painting side by side with friends such as Alfred Sisley. In order to observe the effects of sunlight on water more closely, Monet often worked from a boat-turned-studio. There he could paint nature and leisure activities such as pleasure boating in the open air.

Regatta at Argenteuil, 1872. Oil on canvas, 18 ⅞ x 29 ½ in. (48 x 75.3 cm). Musée d'Orsay, Paris, Bequest of Gustave Caillebotte, 1894

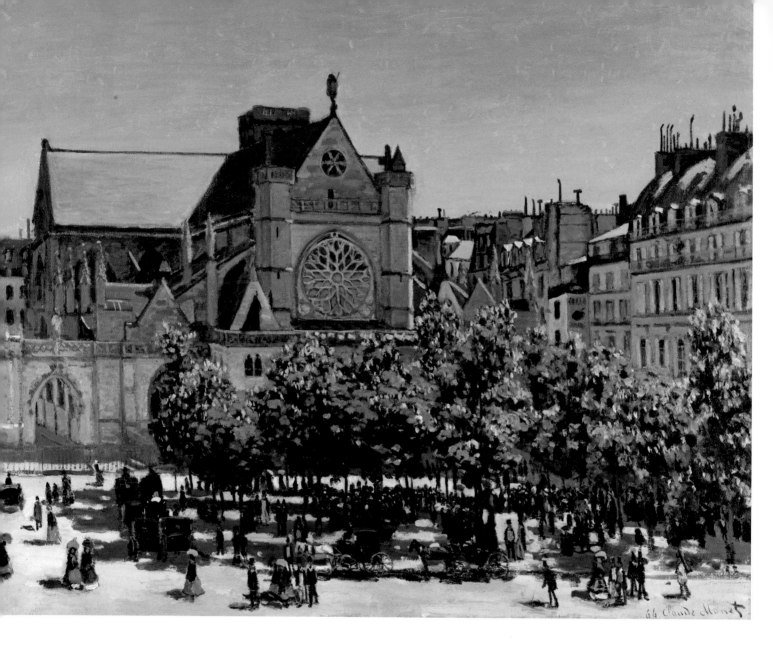

Saint-Germain l'Auxerrois, 1867. Oil on canvas, 31 ⅛ x 38 ⅝ in. (79 x 98 cm).
Staatliche Museen zu Berlin, Alte Nationalgalerie

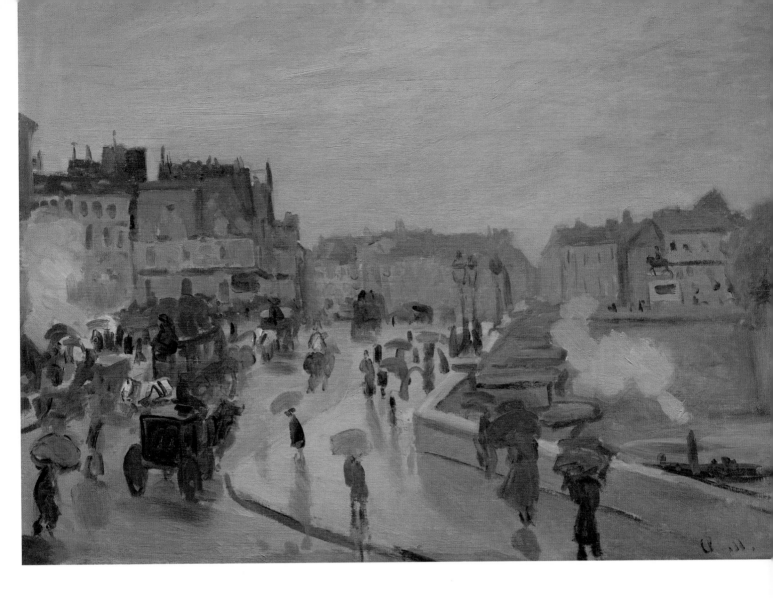

The Pont Neuf in Paris, 1871. Oil on canvas, 21 x 28 ¾ in. (53.3 x 73 cm).
Dallas Museum of Art, The Wendy and Emery Reves Collection

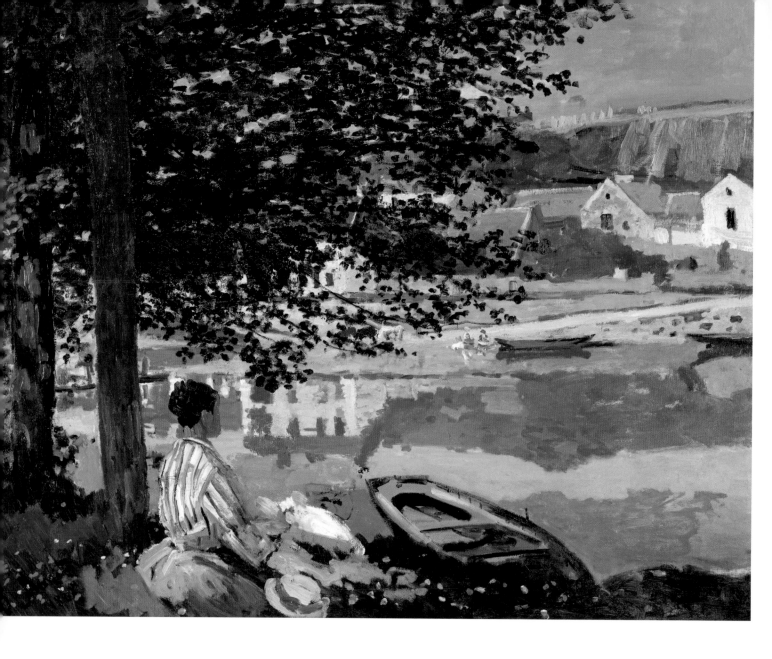

On the Bank of the Seine, Bennecourt, 1868. Oil on canvas, 32 ⅛ x 39 ⅝ in. (81.5 x 100.7 cm).
The Art Institute of Chicago, Potter Palmer Collection

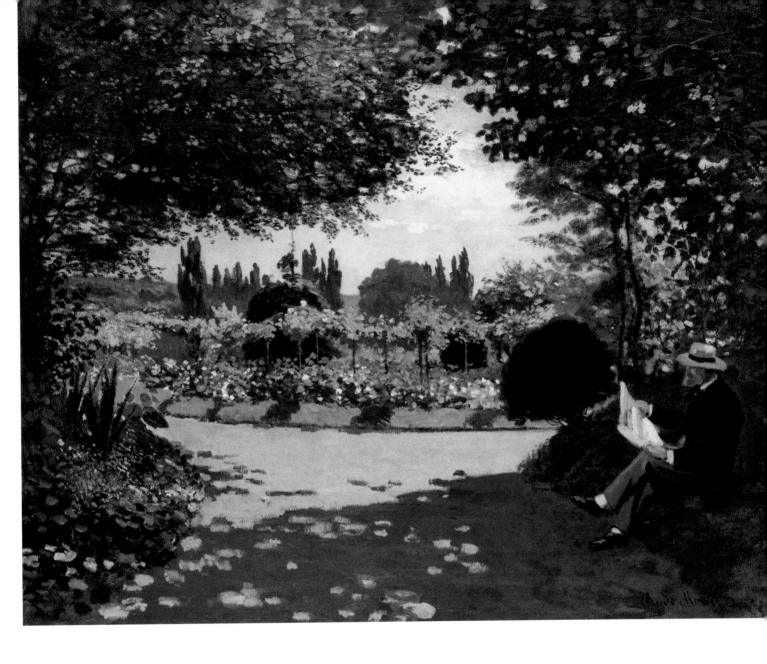

Adolphe Monet Reading in a Garden, 1866. Oil on canvas, 31 ⅞ x 38 in. (81 x 99 cm).
Courtesy of the Larry Ellison Collection

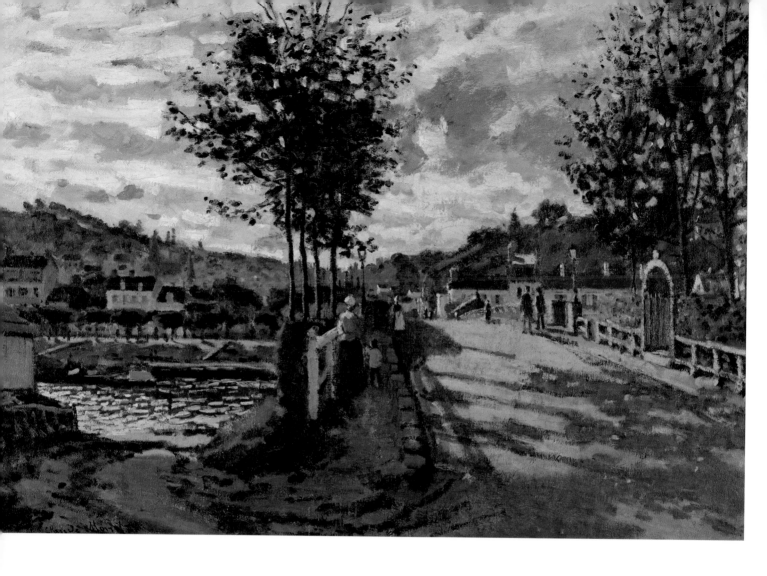

The Bridge at Bougival, 1869. Oil on canvas, 25 ¾ x 36 ⅜ in. (65.4 x 92.4 cm).
The Currier Museum of Art, Manchester, New Hampshire, Museum purchase, Currier Funds, 1949

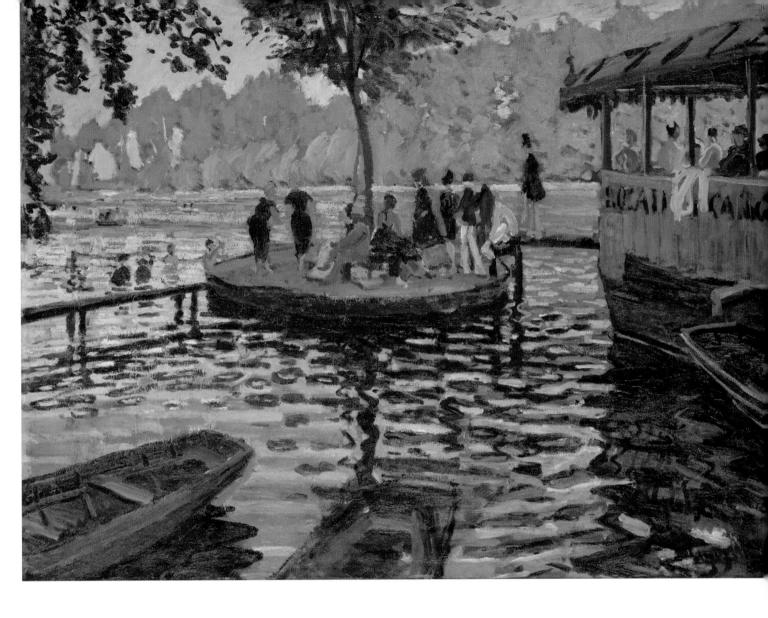

La Grenouillère, 1869. Oil on canvas, 29 ⅜ x 39 ¼ in. (74.6 x 99.7 cm).
The Metropolitan Museum of Art, New York, H. O. Havemeyer Collection, Bequest of Mrs. H. O. Havemeyer, 1929

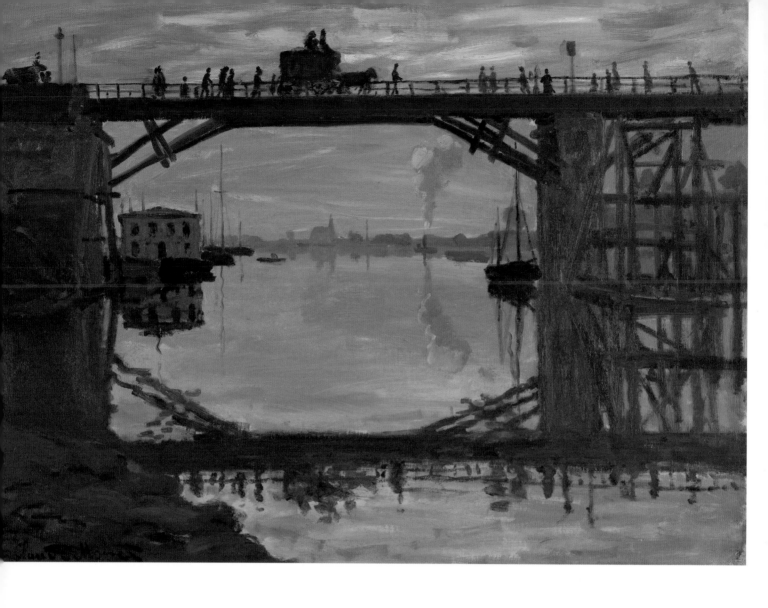

The Wooden Bridge, 1872. Oil on canvas, 21 ¼ x 28 ¾ in. (54 x 73 cm).
VKS Art Inc., Ottawa

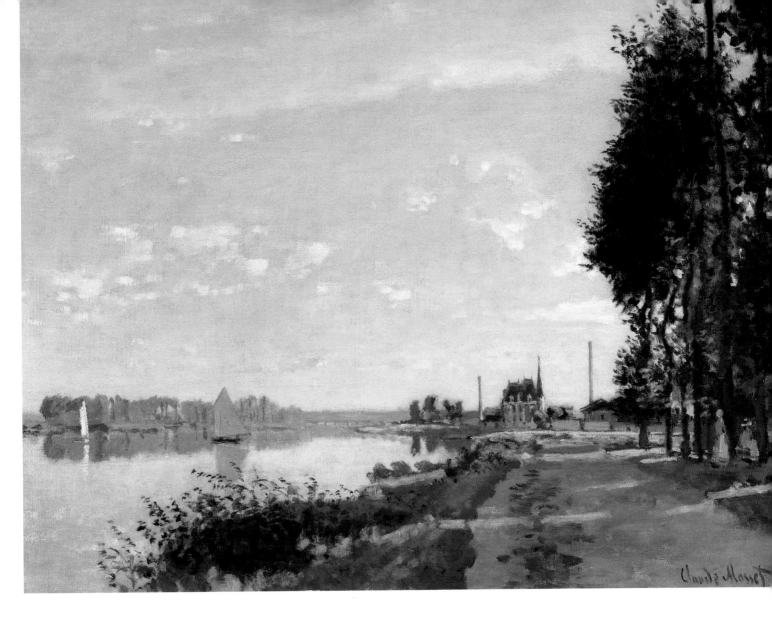

Argenteuil, 1872. Oil on canvas, 19 ⅞ x 25 ⅝ in. (50.4 x 65.2 cm).
National Gallery of Art, Washington, DC, Ailsa Mellon Bruce Collection

Published by the Fine Arts Museums of San Francisco on the occasion of the exhibition *Monet: The Early Years* at the Legion of Honor, San Francisco, February 25–May 29, 2017.

This exhibition is organized by the Kimbell Art Museum in collaboration with the Fine Arts Museums of San Francisco.

Presenting Sponsors
John A. and Cynthia Fry Gunn
San Francisco Auxiliary of the Fine Arts Museums
Diane B. Wilsey
BANK OF THE WEST
BNP PARIBAS GROUP

Conservator's Circle
Mrs. Carole McNeil

Benefactor's Circle
Lisa and Douglas Goldman Fund
Lucinda B. Watson

Patron's Circle
George and Marie Hecksher
Mrs. Anne G. McWilliams
David A. Wollenberg

Additional support is provided by Sonja and Bill Davidow, Mrs. George Hopper Fitch, Carol N. Nelson and Kathryn Urban, the Michael M. Peacock Foundation, Marianne H. Peterson, and Andrea and Mary Barbara Schultz.

The exhibition is supported by an indemnity from the Federal Council on the Arts and the Humanities.

The Library of Congress has catalogued this record under LCCN:2017001902.

Published by the
Fine Arts Museums of San Francisco
Golden Gate Park
50 Hagiwara Tea Garden Drive
San Francisco, CA 94118
www.famsf.org

Max Hollein, Director of Museums
Sheila Pressley, Director of Education
Leslie Dutcher, Director of Publications
Danica Michels Hodge, Editor
Jane Hyun, Editor
Diana K. Murphy, Editorial Assistant

Edited by Danica Michels Hodge
Designed and typeset by Yolanda de Montijo, Em Dash
Printing and binding by Dome Printing, Sacramento, California

Photo Credits
Fig. 1: Wikicommons. Fig. 2 and page 20: © RMN–Grand Palais / Art Resource, NY. Page 6: © Musée d'Orsay, dist. RMN–Grand Palais / Patrice Schmidt. Pages 8, 39: Courtesy of the National Gallery of Art, Washington, DC. Page 9: Erich Lessing / Art Resource, NY. Page 10: Allen Phillips / Wadsworth Atheneum. Page 11: Musée Marmottan Monet, Paris / Bridgeman Images. Page 12: Erik Gould, courtesy of the Museum of Art, Rhode Island School of Design, Providence. Page 13: Cameraphoto Arte, Venice / Art Resource, NY. Page 14: Courtesy of the Union League Club of Chicago. Page 16: Private collection / Bridgeman Images. Page 17: Courtesy of the San Diego Museum of Art. Page 18: Pernille Klemp. Page 19: Courtesy of Sotheby's. Page 21: © RMN–Grand Palais (Musée d'Orsay) / Hervé Lewandowski. Page 22: © Memorial Art Gallery of the University of Rochester. Page 24: Kunsthaus, Zürich / Bridgeman Images. Page 25: Robert LaPrelle / © Kimbell Art Museum. Page 26: Anders Sune Berg. Pages 27, 37: Courtesy of the Metropolitan Museum of Art. Pages 28, 29: Fogg Art Museum, Harvard Art Museums / Bridgeman Images. Page 30: © EPMO (Orsay) / Patrice Schmidt. Page 32: bpk / Nationalgalerie, SMB / Jörg P. Anders. Page 33: © Dallas Museum of Art / Brad Flowers. Page 34: Digital Image 2008 © White Images / Photo Scala, Florence. Page 35: Courtesy of the Larry Ellison Collection. Page 36: Scala / White Images / Art Resource, NY. Page 38: © National Gallery of Canada, Ottawa

Cover: Claude Monet, *Adolphe Monet Reading in a Garden* (detail of page 35)

"Monet amazed everyone,
not only with his virtuosity,
but also with his ways."

PIERRE-AUGUSTE RENOIR

$14.95
ISBN 978-0-88401-149-1

9 780884 011491 >

T2-FHS-098